Cats Are Purr-fect

Other Books by Bob Walker and Frances Mooney

The Cats' House

Cats into Everything

Comical Cats

Crazy Cats

Curious Cats

Cats Are Purr-fect

Bob Walker and Frances Mooney

**Andrews McMeel
Publishing**

Kansas City

Cats Are Purr-fect

02 03 04 05 06 CTP 10 9 8 7 6 5 4 3 2 1

Library of Congress Cataloging-in-Publication Data
Walker, Bob.
 Cats are purr-fect / Bob Walker and Frances Mooney.
 p. cm.
 ISBN 0-7407-2244-1
 1. Cats—Pictorial works. 2. Photography of cats. I. Mooney, Frances. II. Title.

SF446 .W258 2001
636.8'0022'2—dc21 2001044984

www.catshouse.com

Book design by Bob Walker and Frances Mooney

Attention: Schools and Businesses

Andrews McMeel books are available at quantity discounts with bulk purchase for
educational, business, or sales promotional use. For more information, please write to:
Special Sales Department, Andrews McMeel Publishing, 4520 Main Street,
Kansas City, Missouri 64111.

Acknowledgments

Occasionally, the dazzling vitality of another completely captivates us. It's joyful while we're together and sorrowful when higher paths call. We would like to dedicate *Cats Are Purr-fect* to TomCat, Sue Reiter, and Frank Daniels, who immeasurably enriched our lives and will always guide our thoughts.

Most of us have ideas bursting to be shared with others. Well, why not put your thoughts on paper and illustrate them with photographs? Voilà, you're a photo author! Making a book is easy (if you have supportive friends and family, tolerant subjects, a nurturing editor and agent, and a publisher willing to bet the family farm on you).

So many four-leggeds and two-leggeds have made *Cats Are Purr-fect* possible that it would be impossible to give credit to all. Nevertheless, we would like to extend our appreciation to those we can recall at this time. Thank you (and everyone we forgot to mention) for providing us with your guidance, support, and friendship: Laurie Fox, our brilliant agent at the Linda Chester Literary Agency, who got the author ball rolling for us; Kathy Viele, our unflappable editor who always is right; Andrews McMeel Publishing, for making our dreams come true; Gerri Calore, Denise Johnston, and their wonderful staff at the National Cat Protection

Society, for filling our home to the rafters with deserving kitties; Fletcher Hills Pet Clinic, Dr. Harold Stephens, Dr. Cheryl Clark, Kimberlee Miskovsky, Colleen Giardina, and Cristina Reyes, for keeping our family fit for print; Dennis Reiter at Chrome Film and Digital Services, for life-long support and impeccable standards; the Cat Writers' Association, for encouraging excellence; and our friends and family, for steadfastly standing by us and enduring our lapses: James Ard; Lee Austin; John Bergstreser and Karen Truax; Kay, Margie, and Tiger Crosbie; Tim, Sherry, Thumper, and Zane Crump; Dennis, Barbara, Christine, Andrew, and Jenny Culleton; Omer Divers, Katherine Mooney, and Rosie Divers-Mooney; Dave Garcia; Louis Goldich; John Hilbig and Laura Cunningham; Melinda Holden; Naomi Kartin; David Katz; Mary Beth Link and Norman Sizemore; Barbara Murray; Pat Rose; Bryan, Carrie, and Austin Soler; Jan, Linda, and Puddy Tonnesen; Hitoshi, Terri, Ken, Issey, Ralphie, and Yohji Tsuchida; and Mom and Dad and Mom (Wayne and Nora Miller; Stelle Mooney), our loving parents who've endured it all and nourish us to this day.

We can't call this cat book "complete" without thanking the cats: Sissypoo, George, Edward, Little Kitty, Harry, Gina, Herman, Alexander, Cornelius, Mr. Pie, Betsy, Dink, Lydia, Elizabeth, Emma, Virginia, Julia, BoyCat, Athena, Miranda, Charlie, Snoopy, Beauregard, Benjamin, Calafia, Simon, Joseph, TomCat, Terri, Celeste, Jerry, Jimmy, Bernard, Denise, Frank, Molly, Louise, Charlotte, Gus, Elliott, Stella, Eddie, and, of course, Sasha, the most catlike dog a cats' house could have.

Cats Are Purr-fect

In the early days of Egyptian pyramids, cats were gods, and today, they're not about to let us think otherwise. Centuries of felines have trained us to treat them with reverence. How else can we explain our behavior? At all hours, we allow our naps to be interrupted, because our cats would like a snack. Before we eat, they get fed first. At work, we talk about our cats more than our friends or family. We come home and greet our felines first. They get annual check-ups; our physicals are postponed. Face it, we're putty in their paws. No one can convince us otherwise; we know that cats are purr-fect . . .

because they reach for the possible

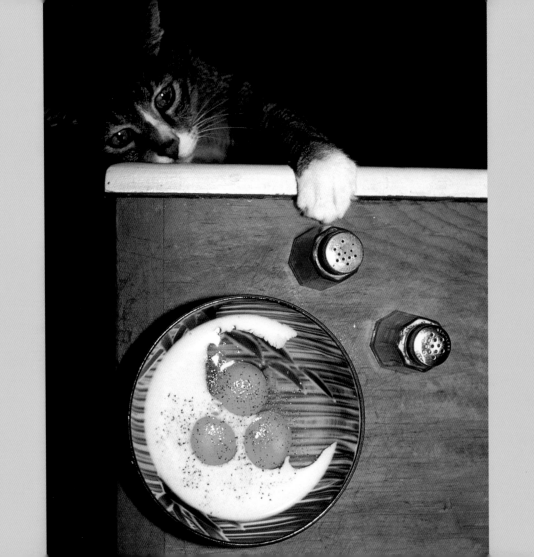

because they're

always listening

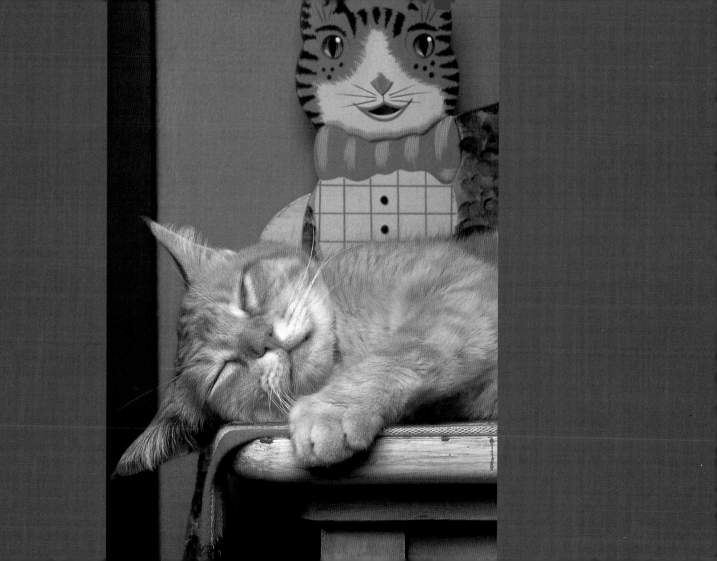

because they *help* *themselves*

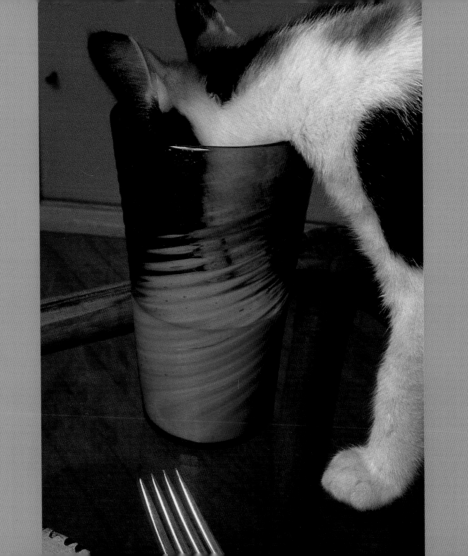

because they proudly share their catch of the day

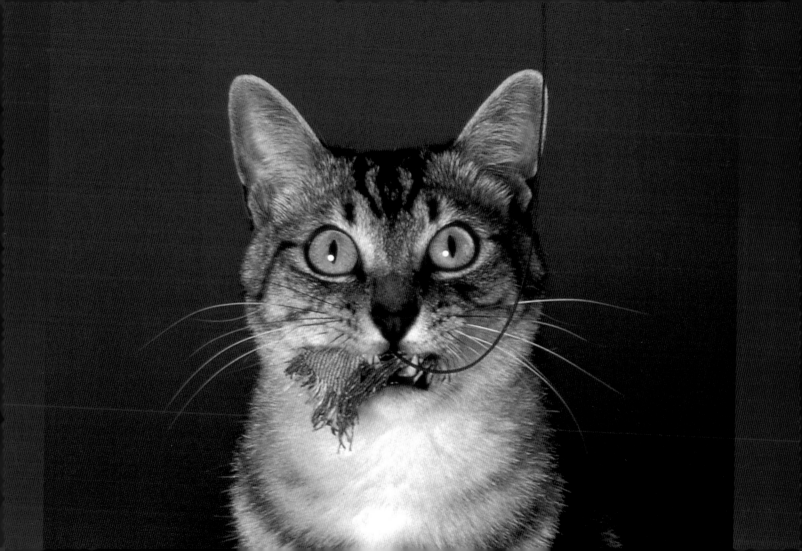

because

they

rarely

meet

a

food bowl

they don't like

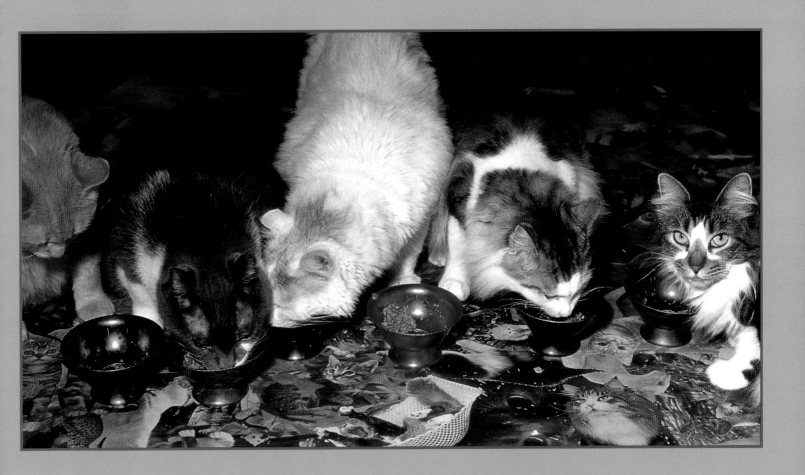

because they **help** with *life's* m e s s e s

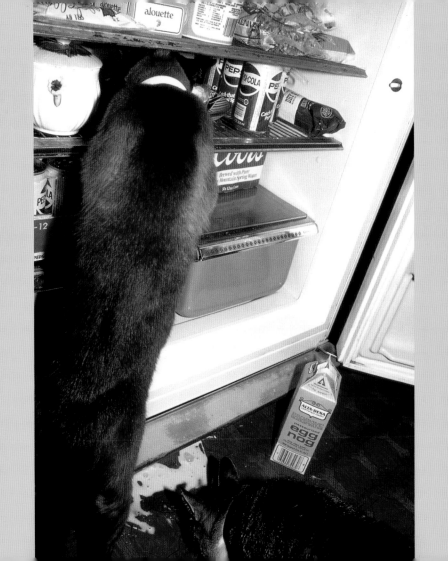

because
they have good

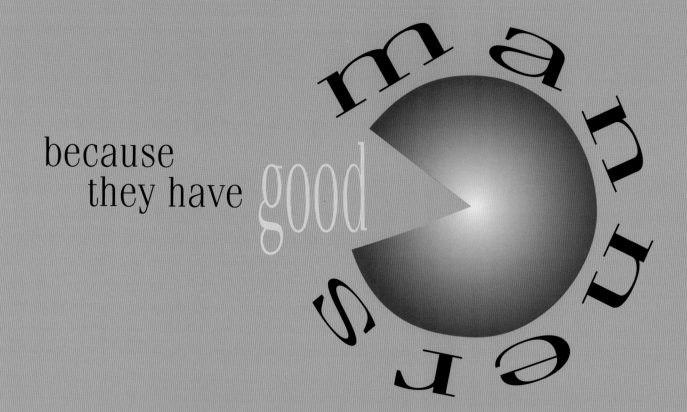

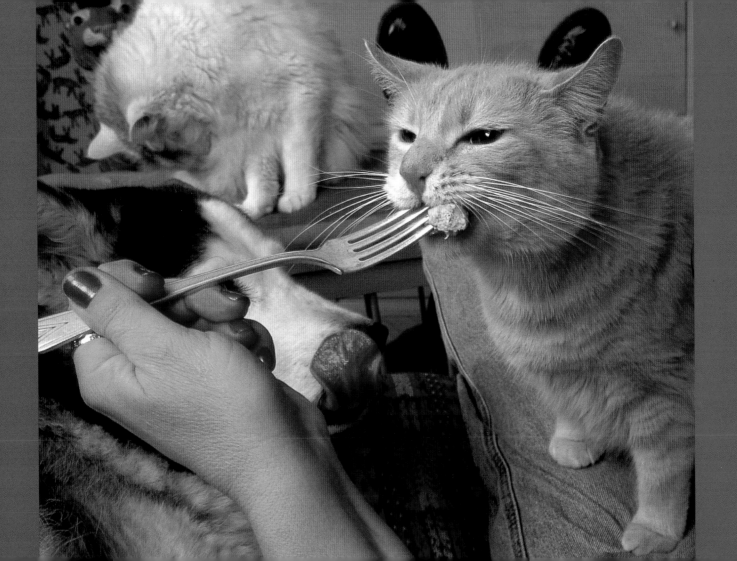

because they follow their noses

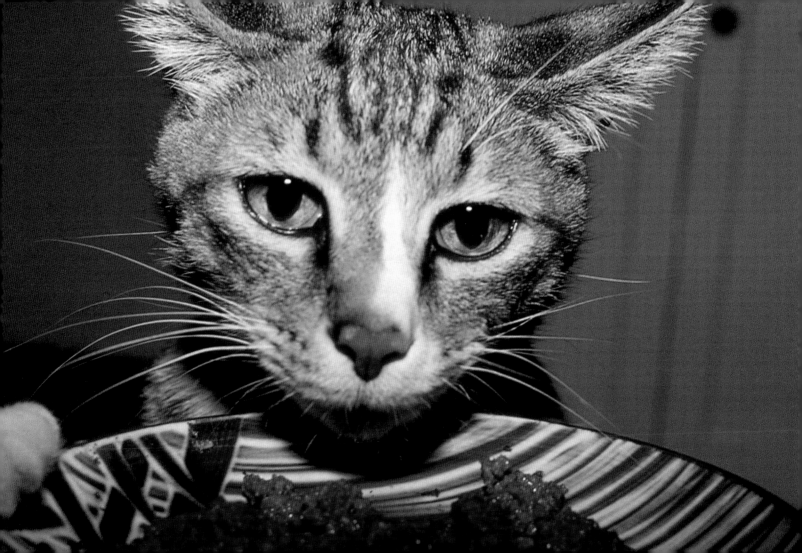

because they store up for lean times

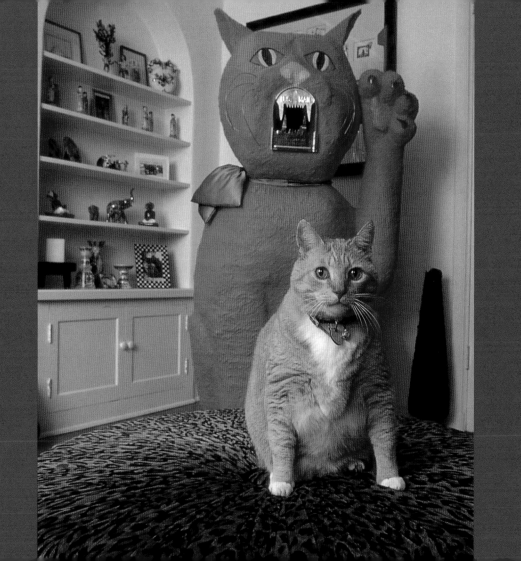

because
they
trust us when
they
need help

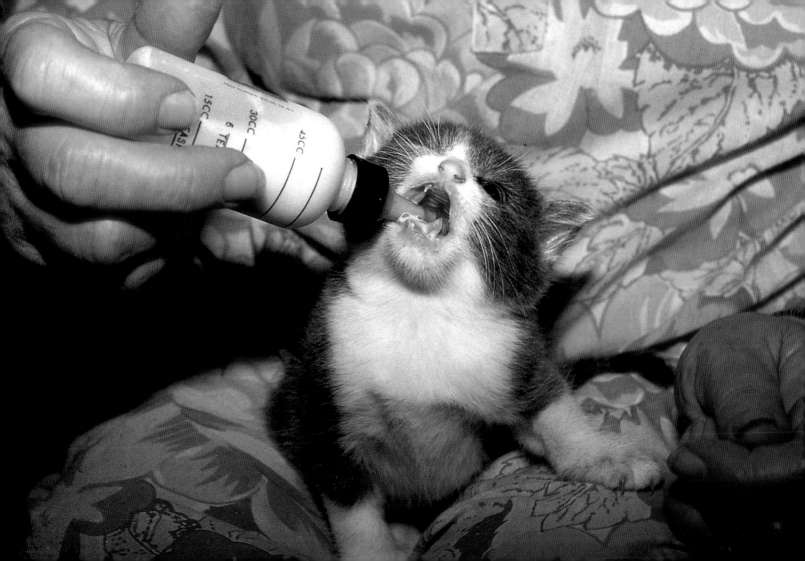

because they don't worry about dirty dishes

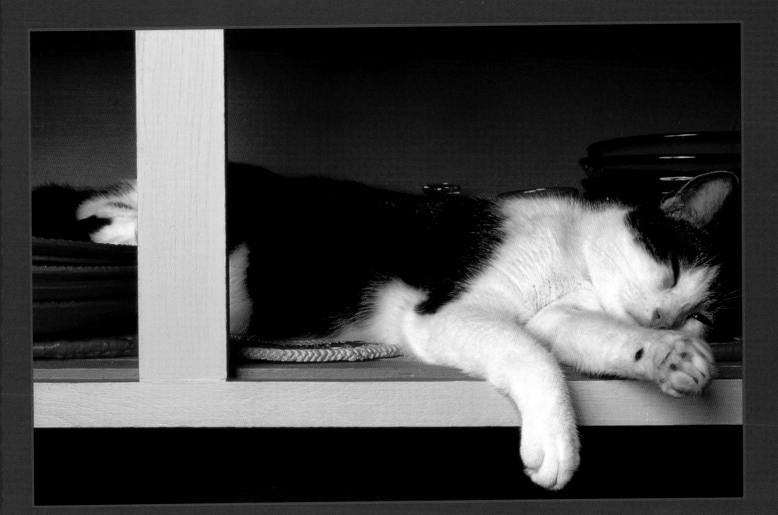

because they know what they want

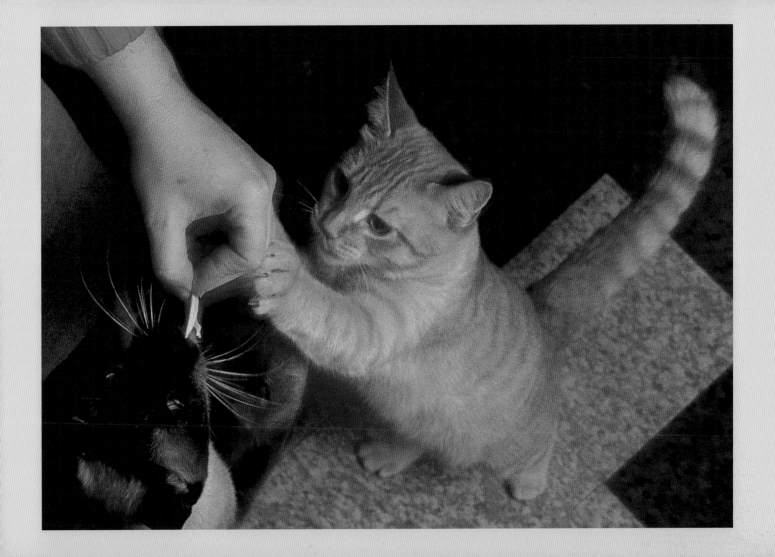

anything

lick

because they can

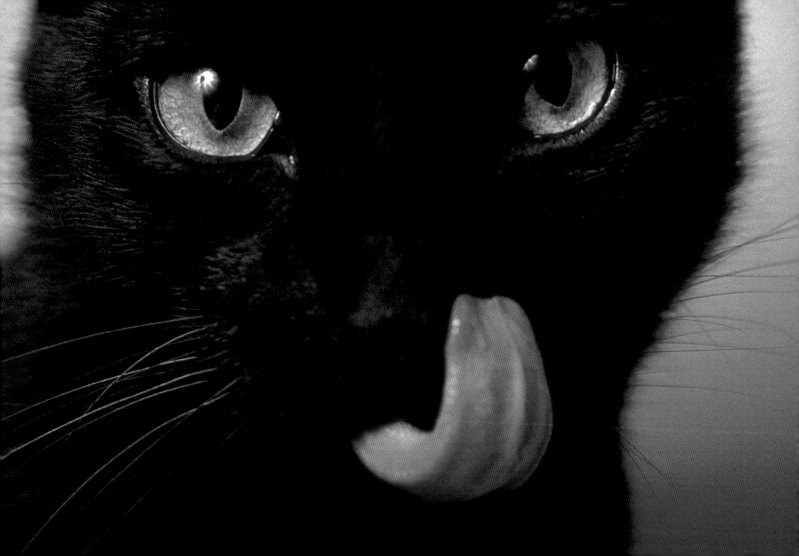

because they don't accept *no* for an answer

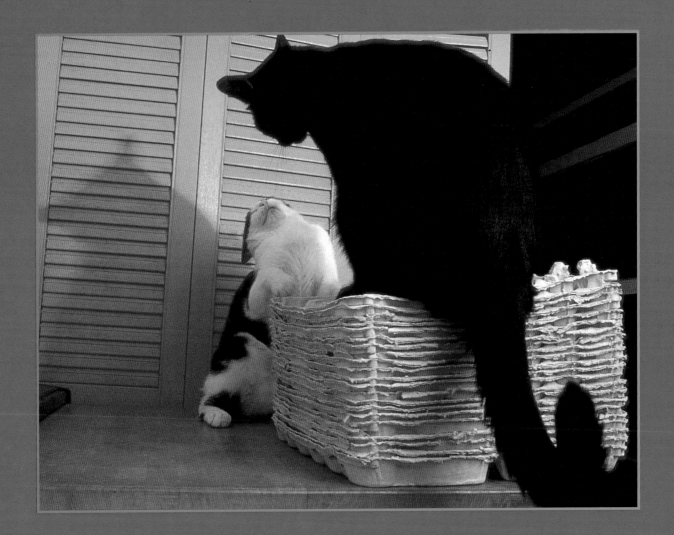

because they
know when
to act
Surprised

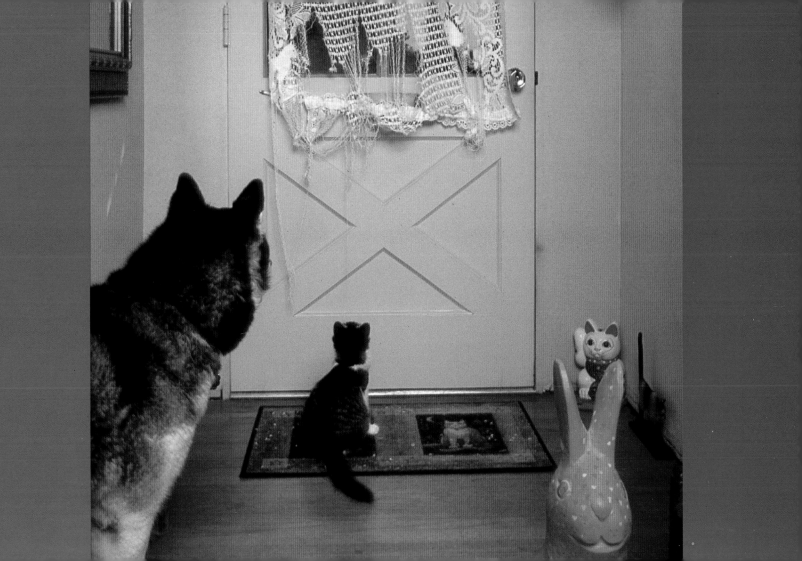

because they inspect all

p

new arrivals

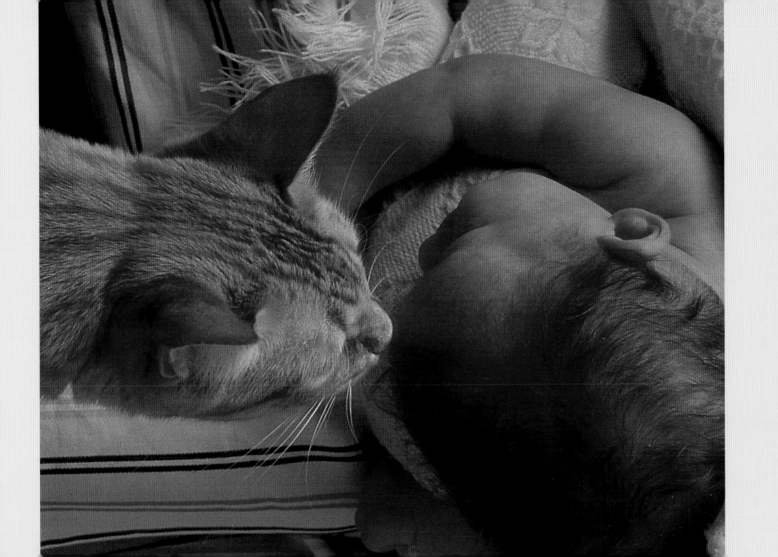

because they *grounded* keep us

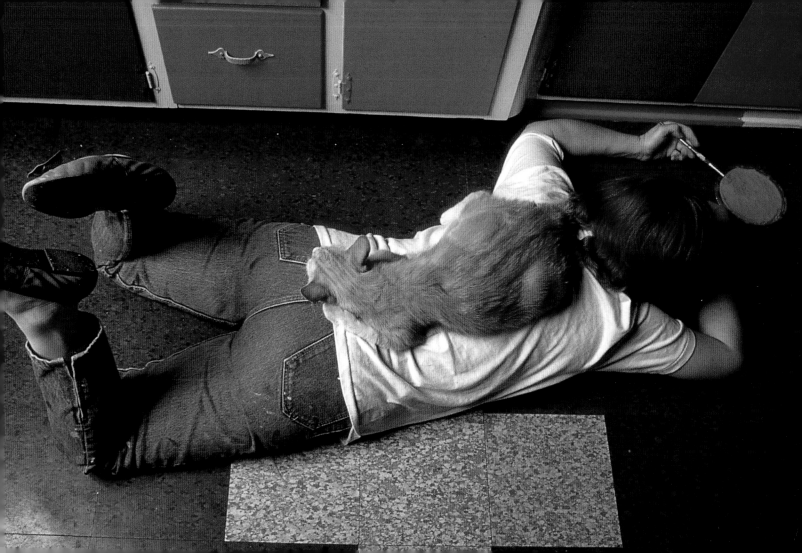

because they shield us from harmful rays

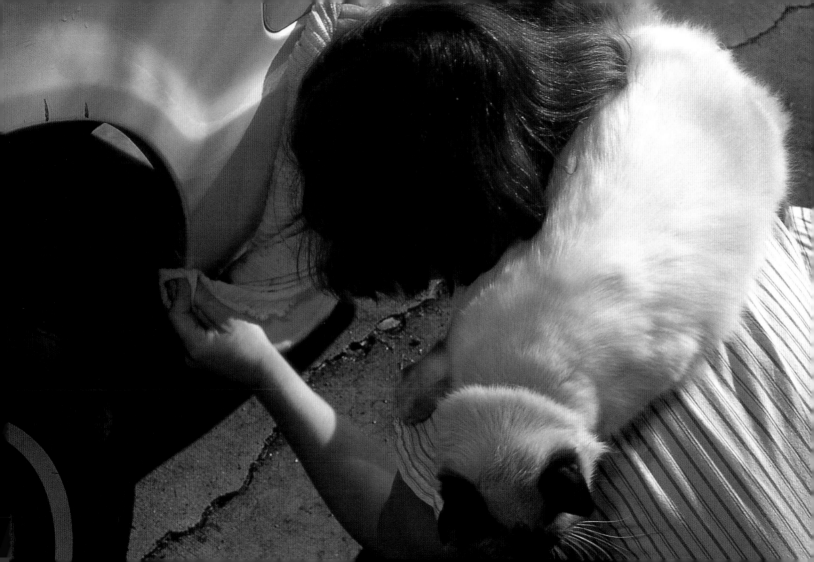

help

because us

they

relax

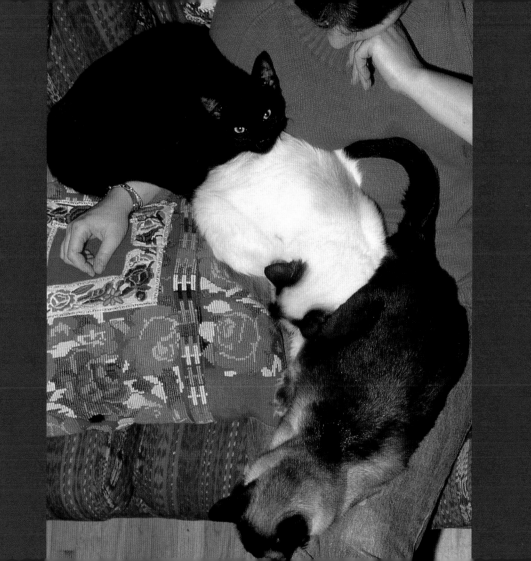

because they

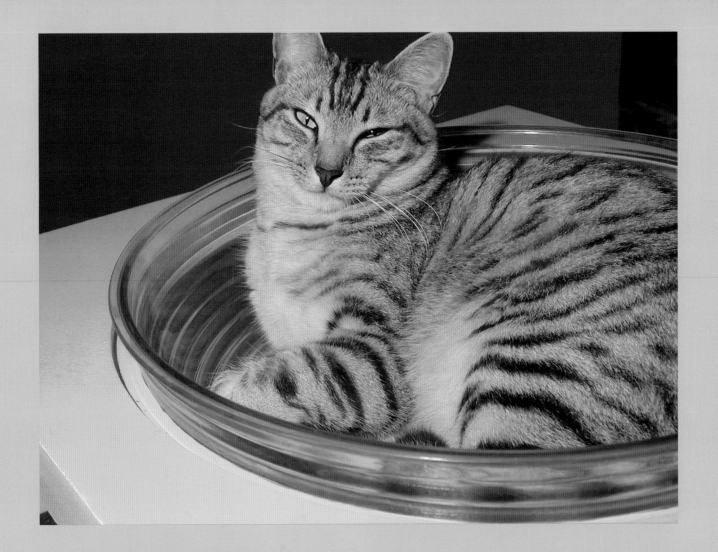

because
they
are
always
ready
to
be
admired

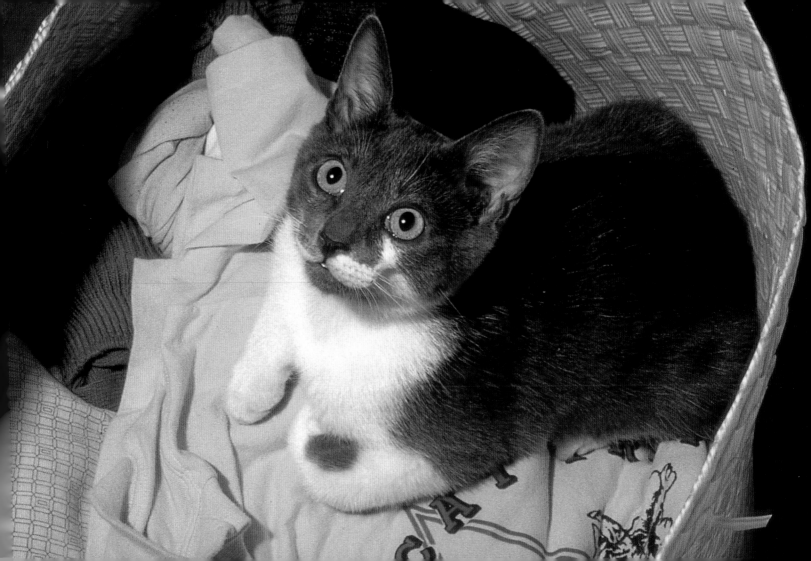

because they're not self-conscious

44

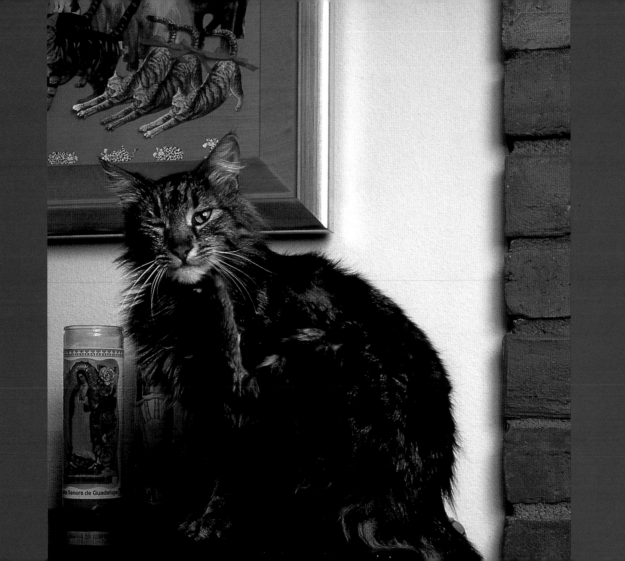

because they
can
be

martyrs

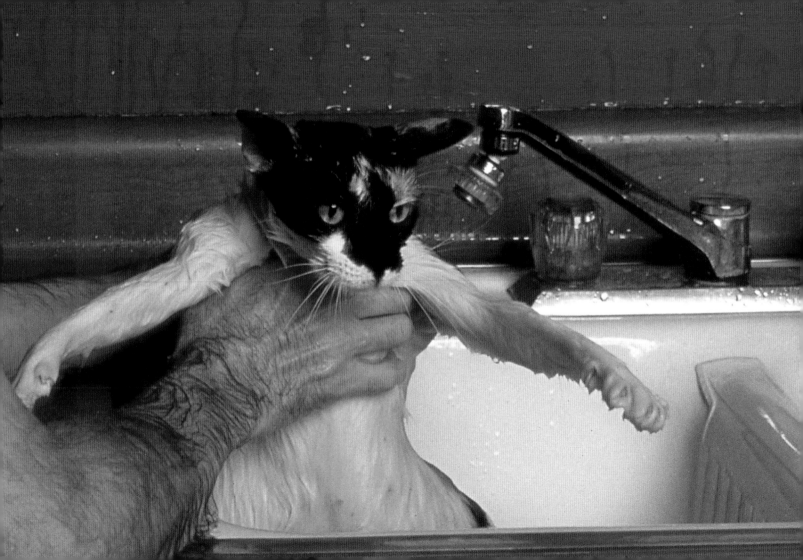

because they

suffer silently

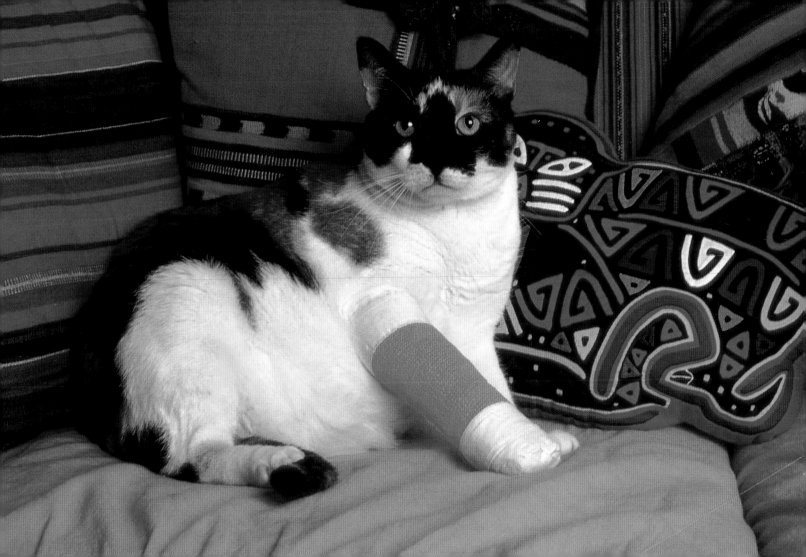

because they
aren't discouraged

by bad hair days

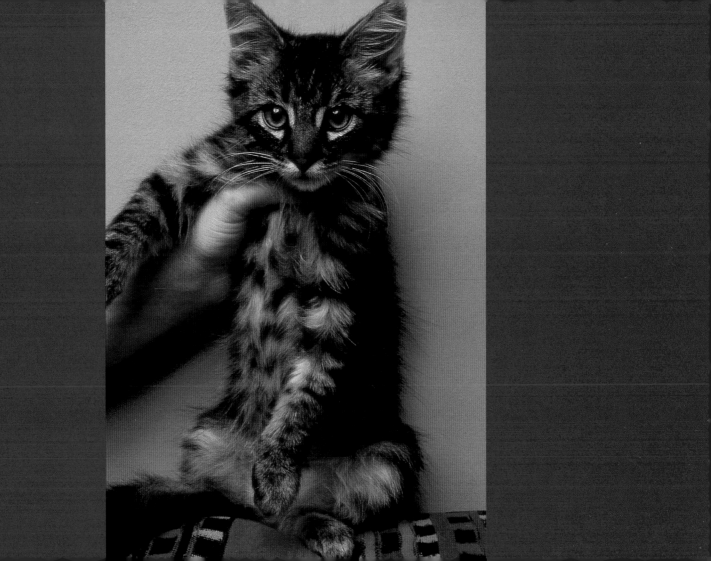

because they are

low maintenance

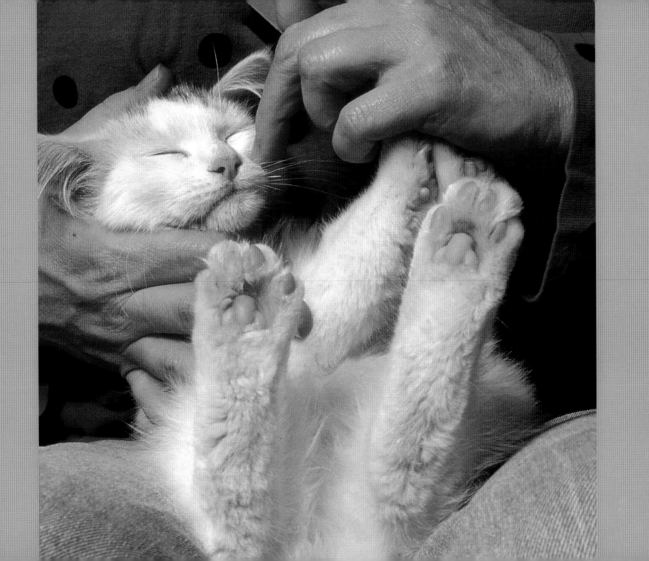

the closer we look,
because the better they look

54

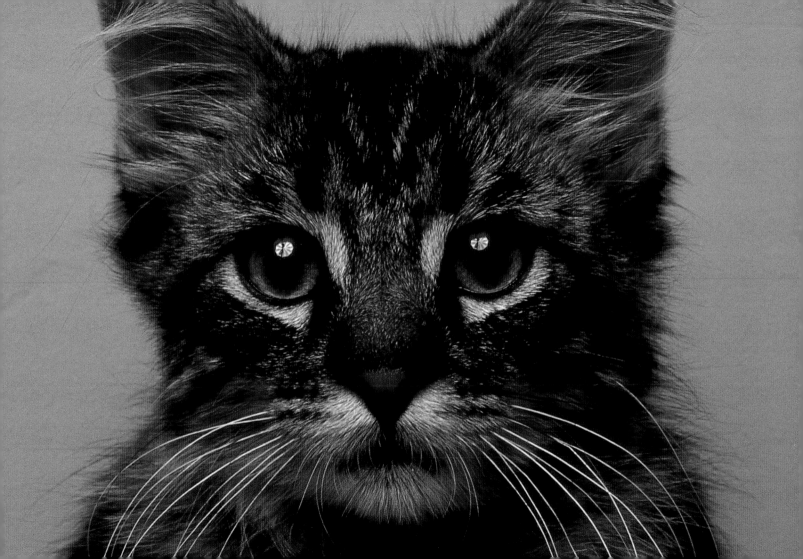

because they are hard to impress

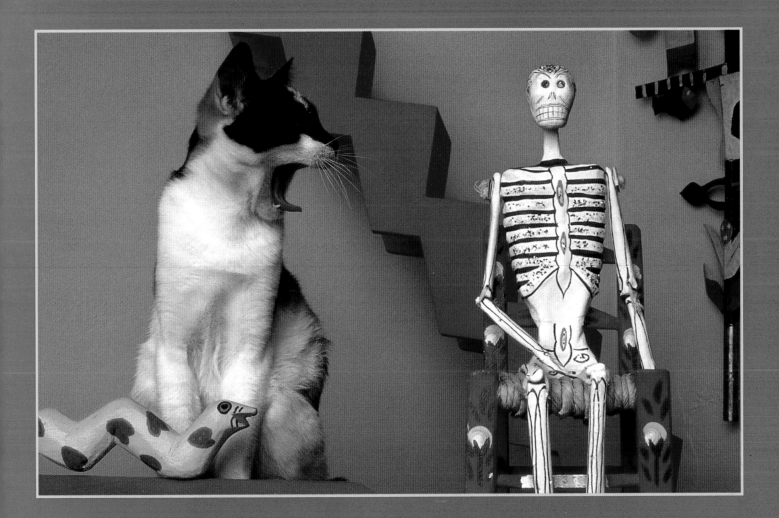

because they are music to our ears

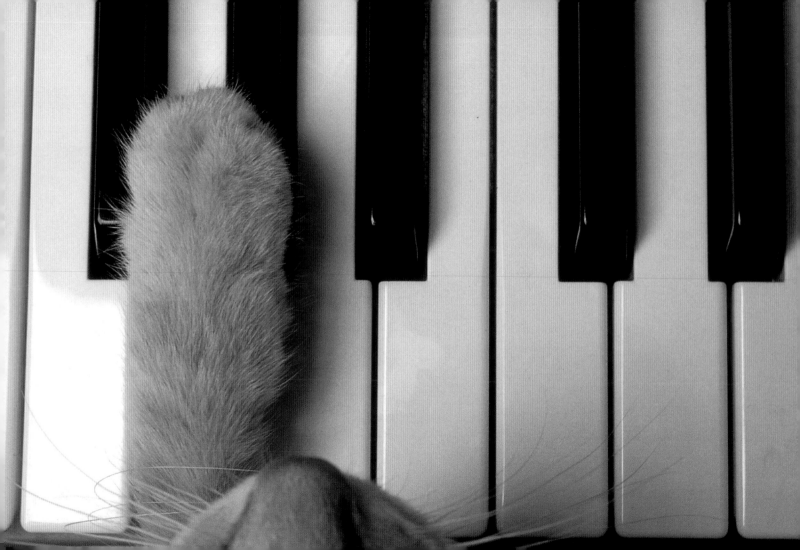

...because they adore a party...

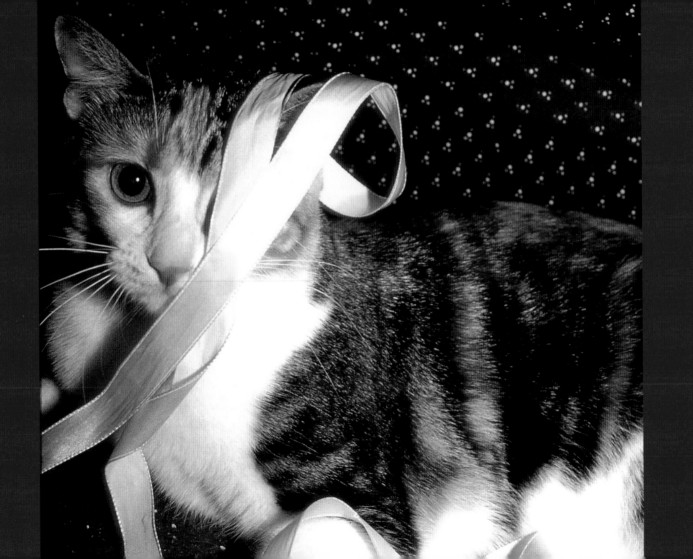

because they enjoy making mischief

because they have their own point of view

our cupboards

when

know

us

let

they

because

are

bare

because theY don't let anything get in their way

because they protect us from creepy crawlers

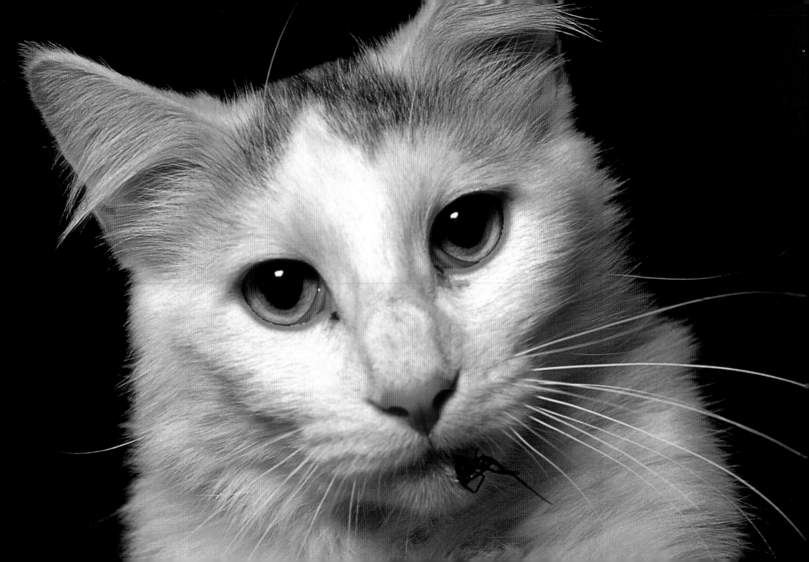

because they find fun in everything

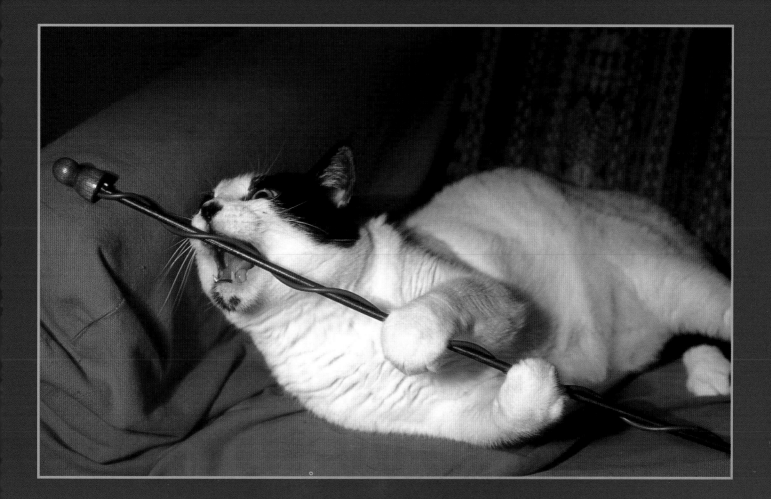

because they are alert

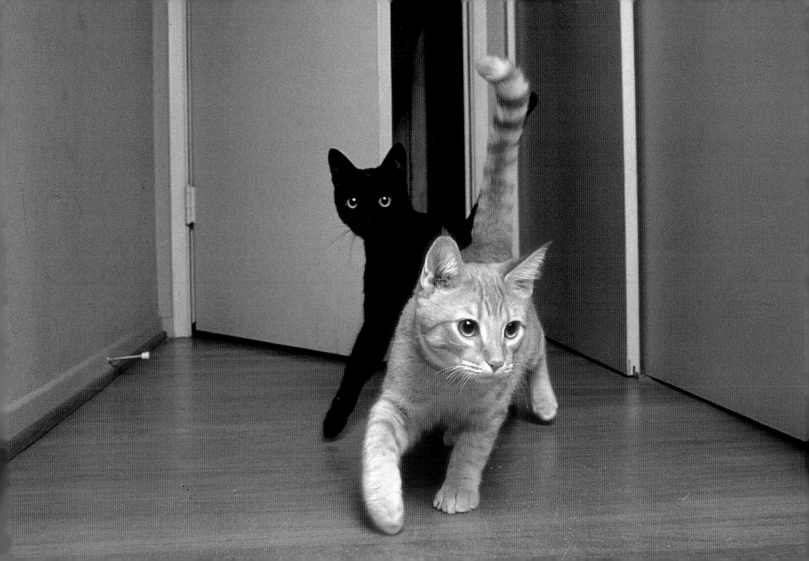

because they are intense

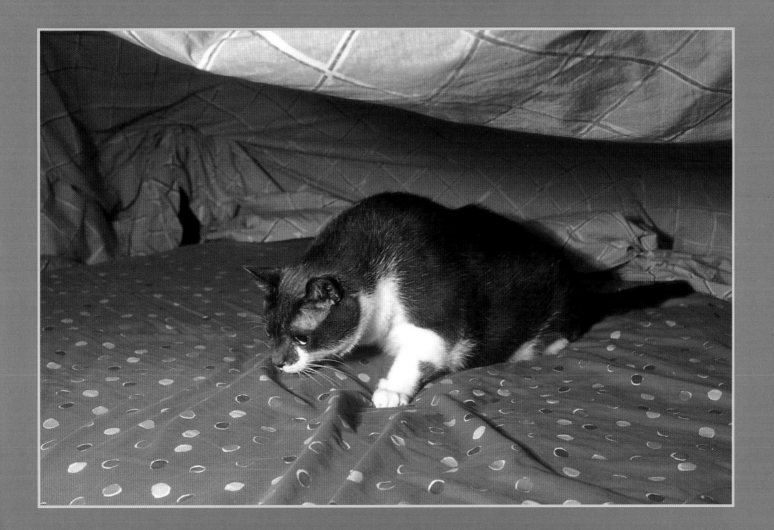

They disappear so easily . . . because they can

because they pop up

in strange places

80

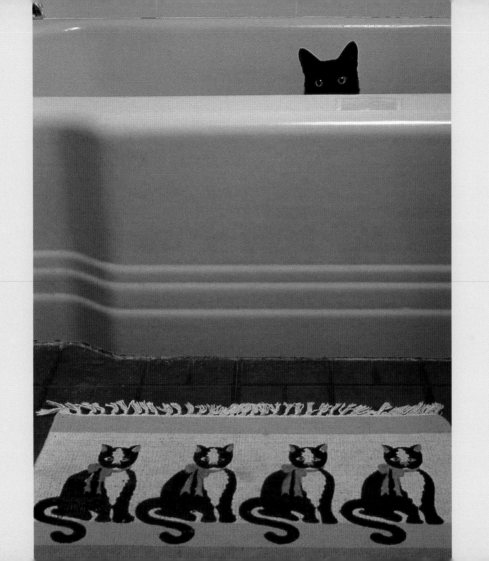

because they

warm our towels

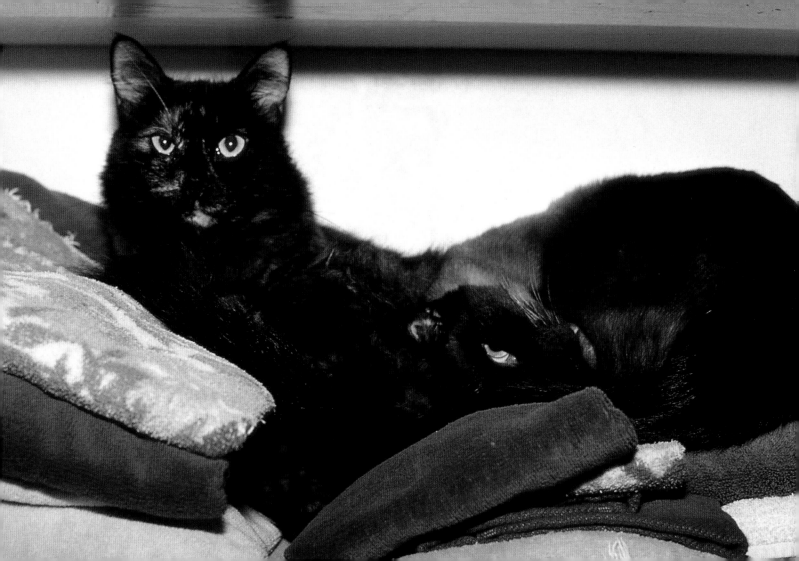

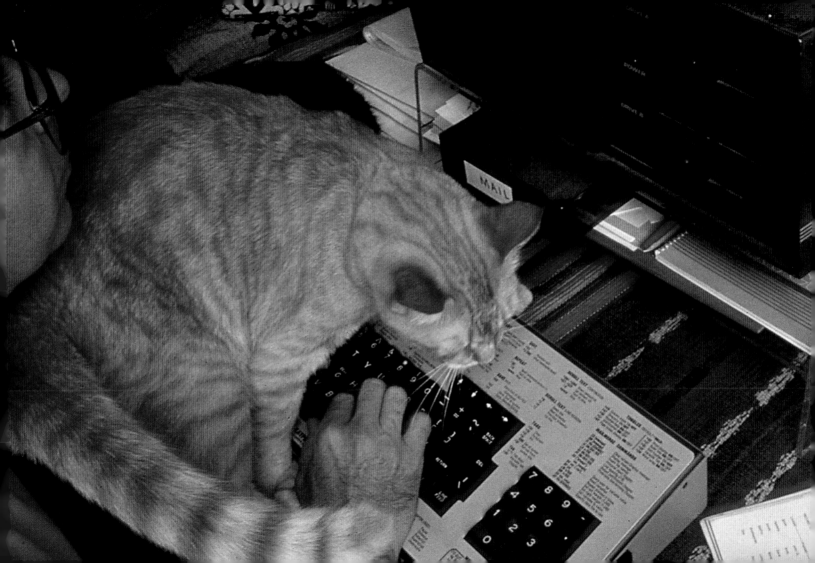

because they

think

box

outside the

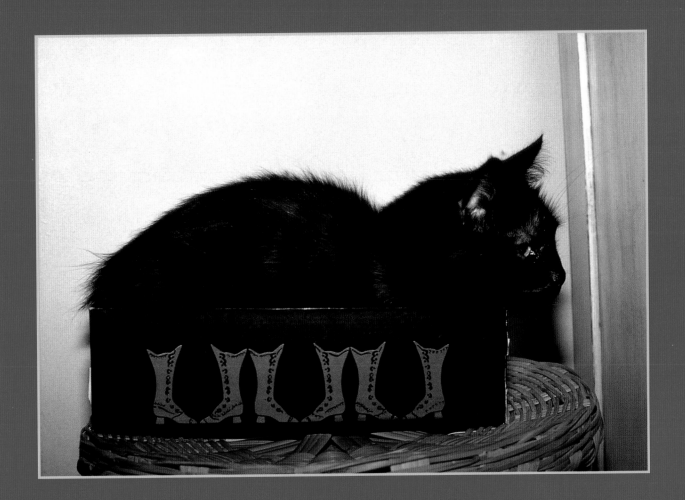

helping paw

because they are always willing to lend a

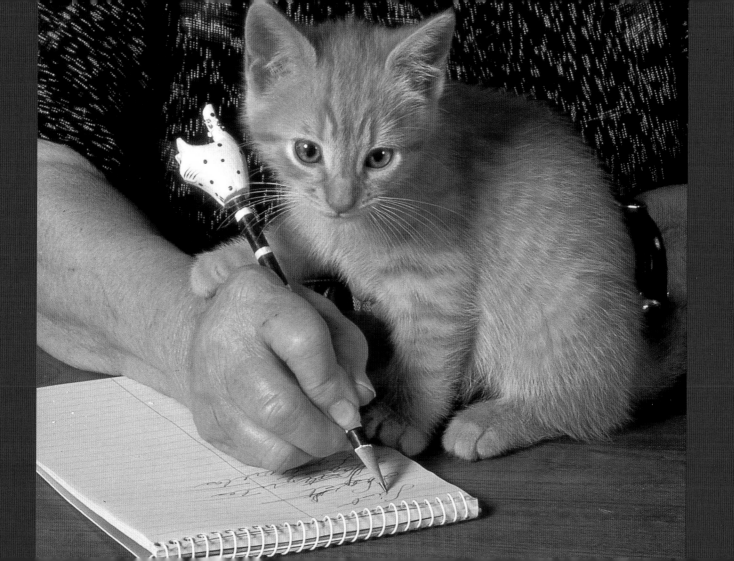

because they approach problems

from all angles

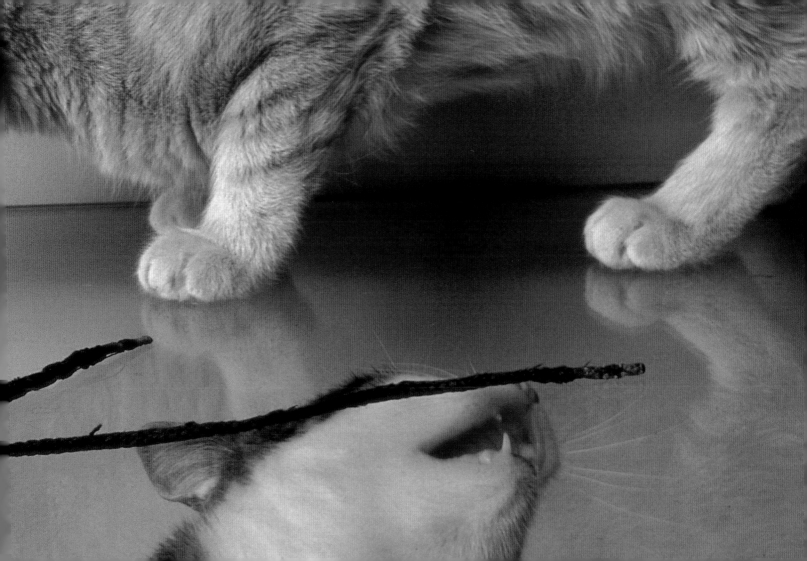

because they

don't drink and drive

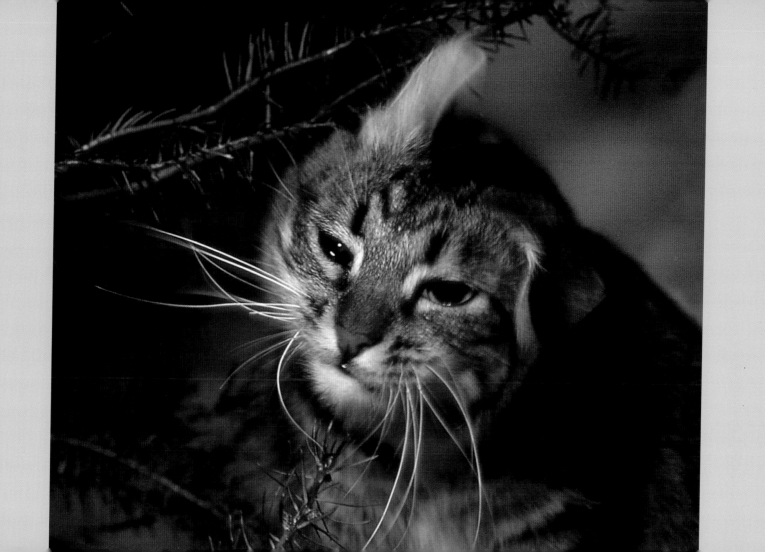

easily to

Daylight Savings Time

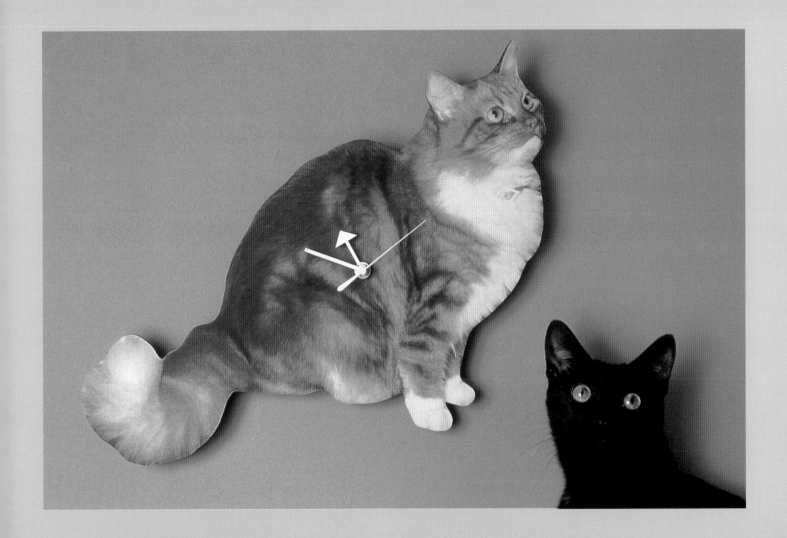

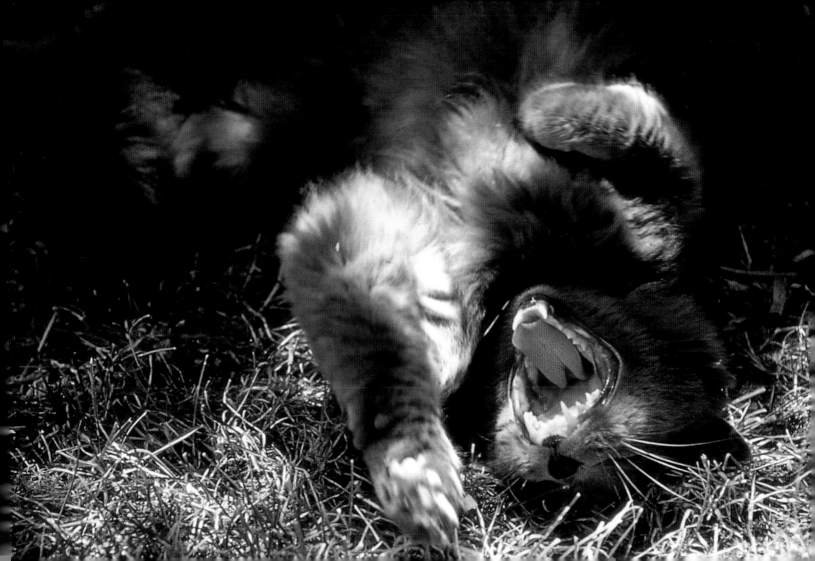

they're natural because explorers

the best seats

because they share

in the house

because
they

defend

our
(their)
laps

because they *don't* let **others** get in their way

because they usually let you win

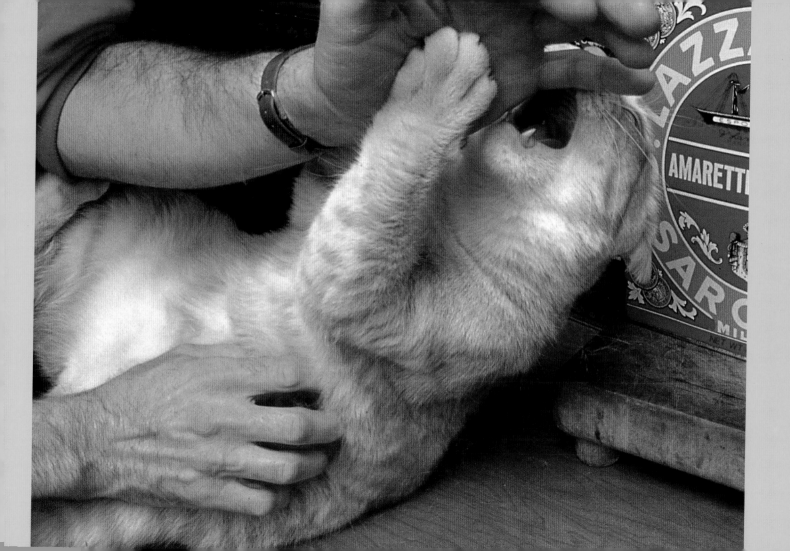

because

we amuse them

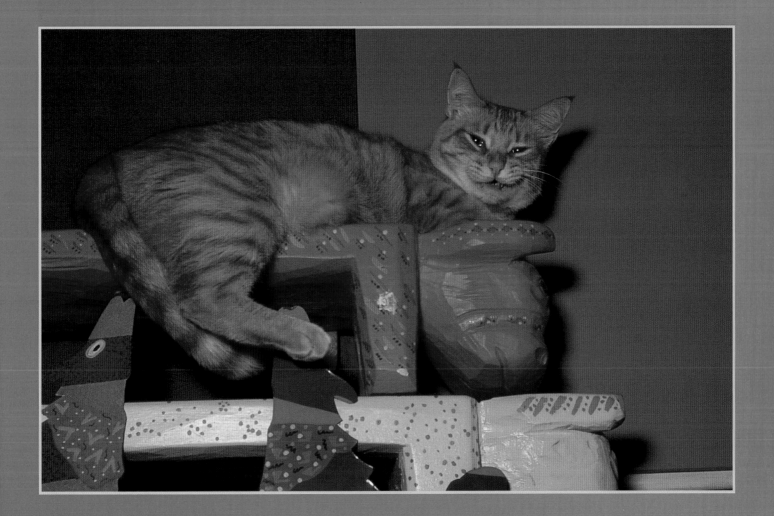

because

they always come out on top

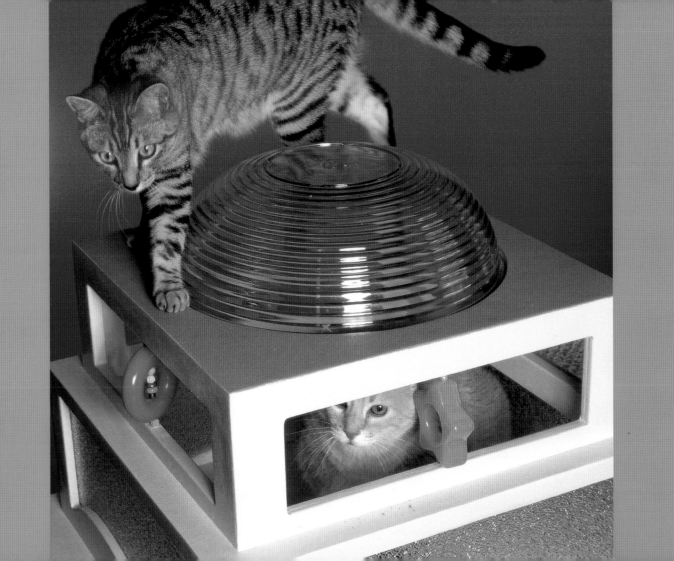

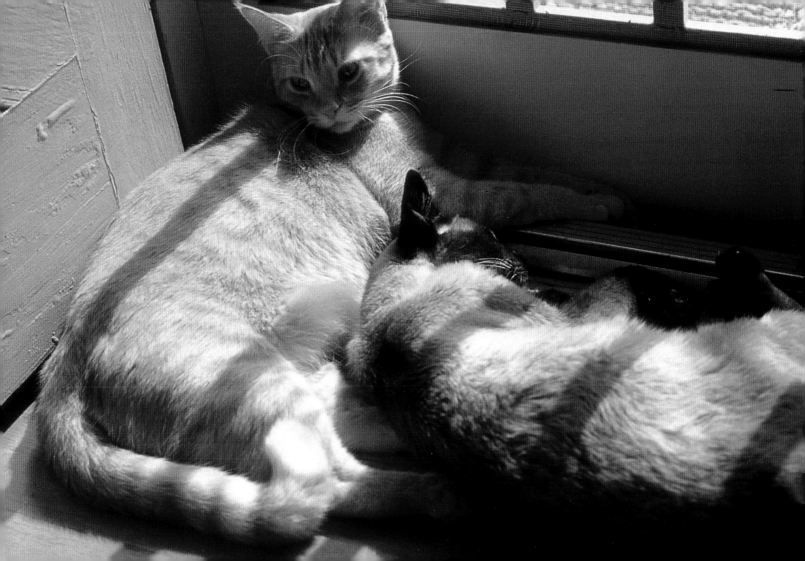

they can be

because

spotted

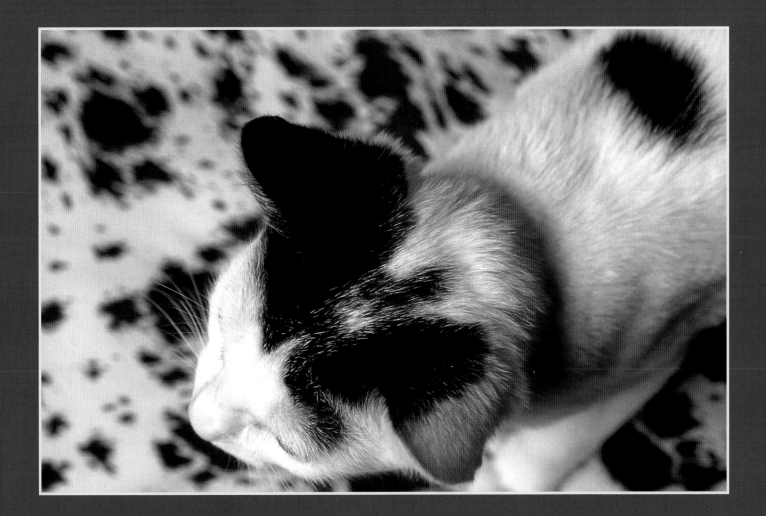

because they are not afraid to speak up

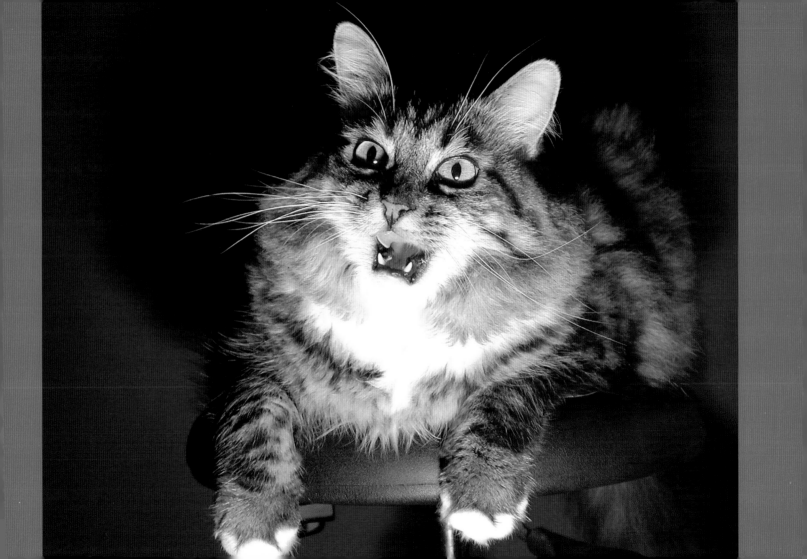

because they know how to have fun

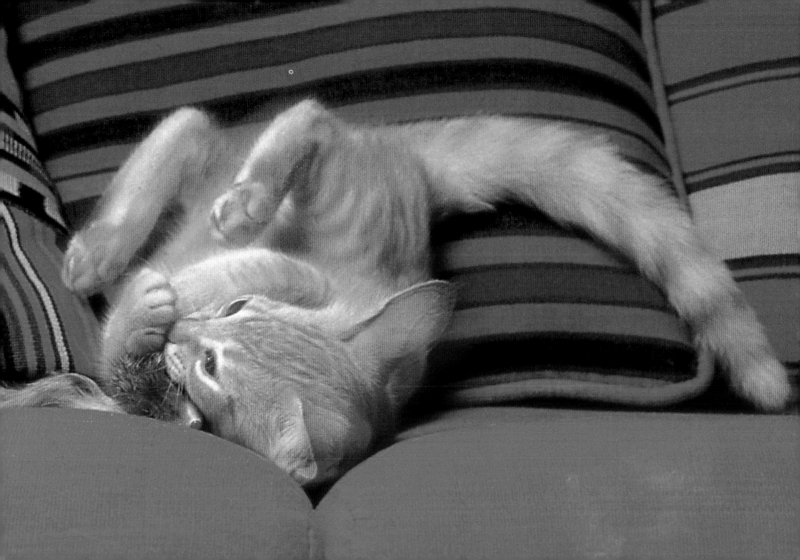

because they **boldly** go where no cat has gone before

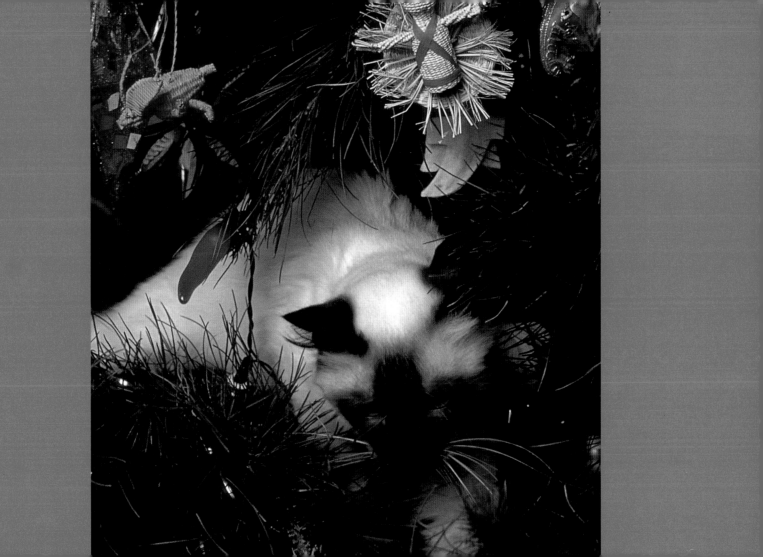

because they don't let anything get by them

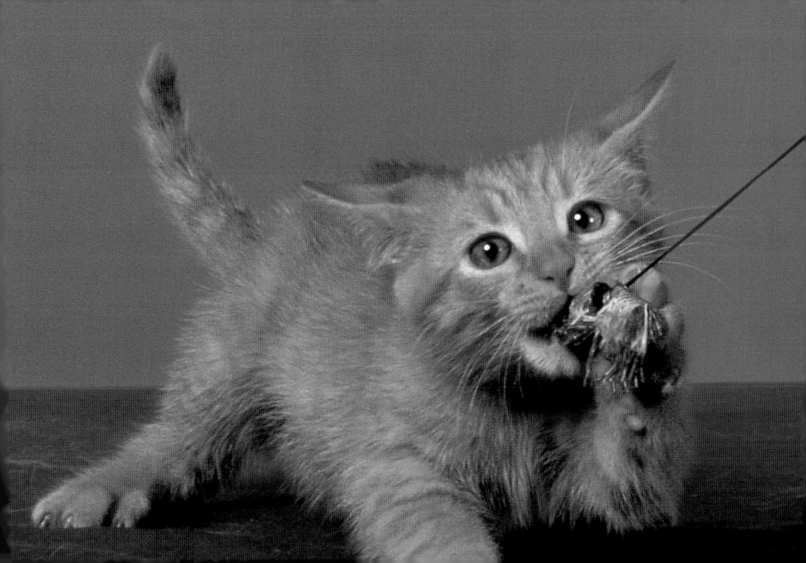

curious

because they are incurably

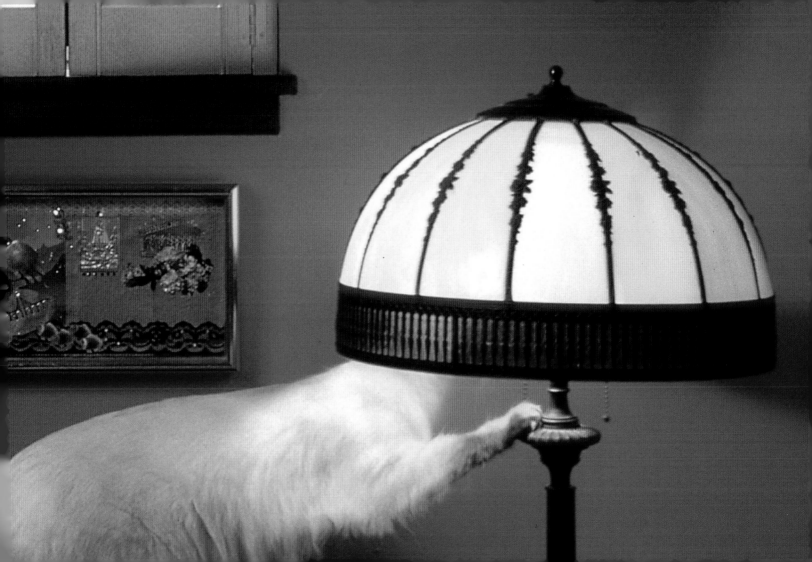

because, for them, all the world is a stage

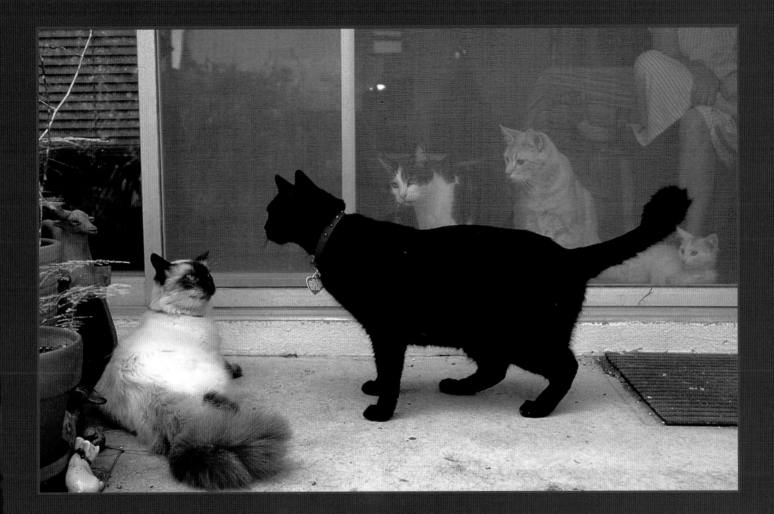

because they

know

their

limits

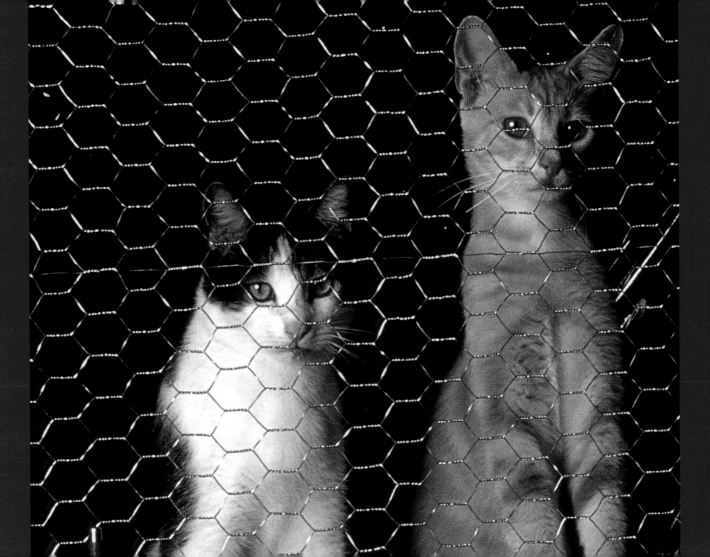

because they are our gardens, guardians,

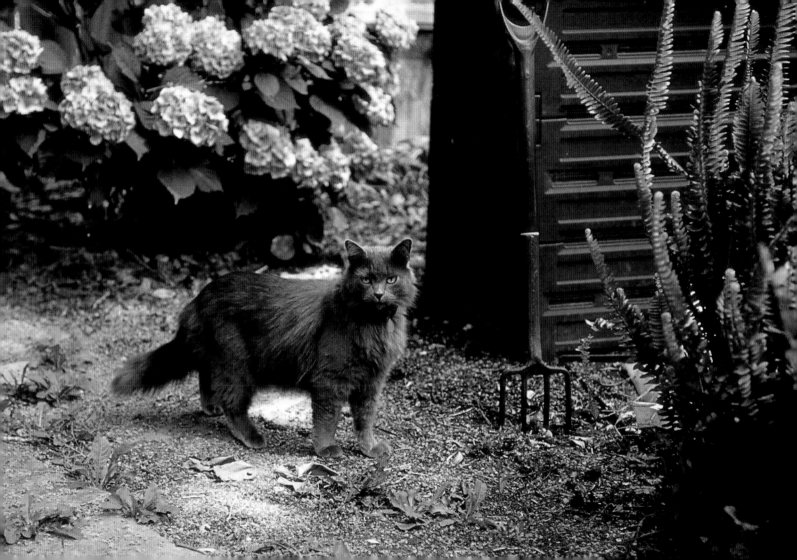

because they take comfort in the company of others

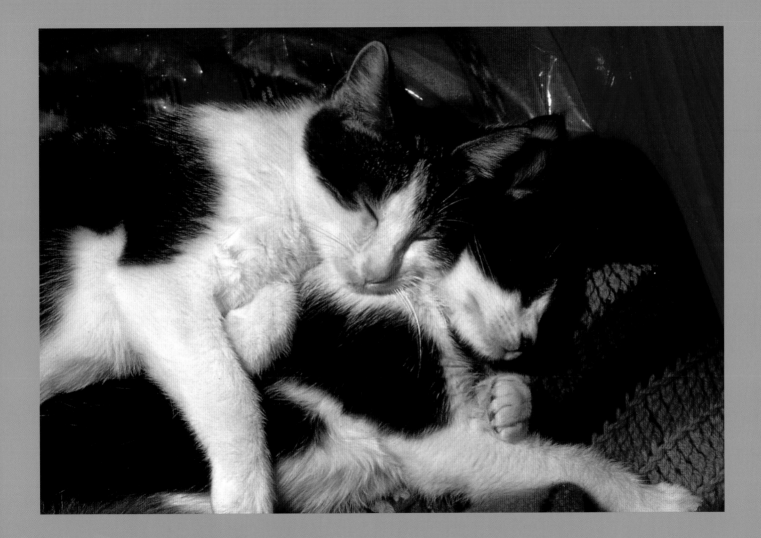

becuse they love one another

134

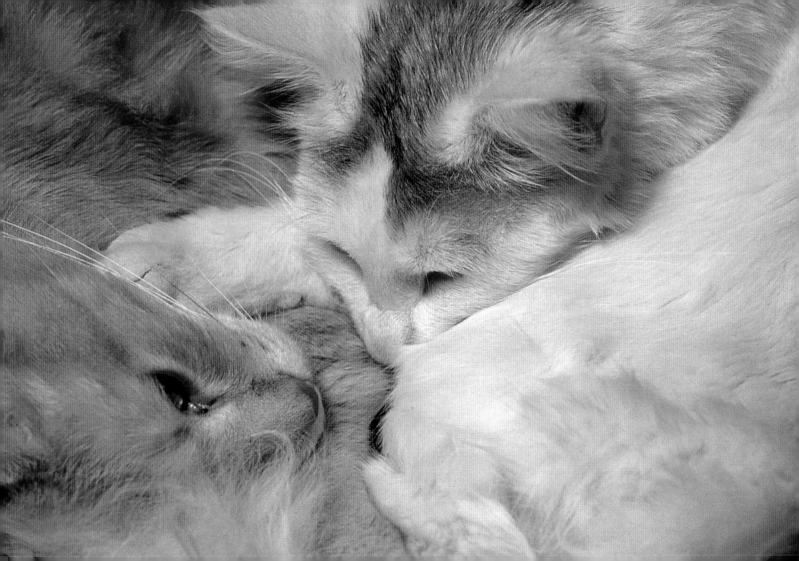

stories because they enjoy good bedtime

136

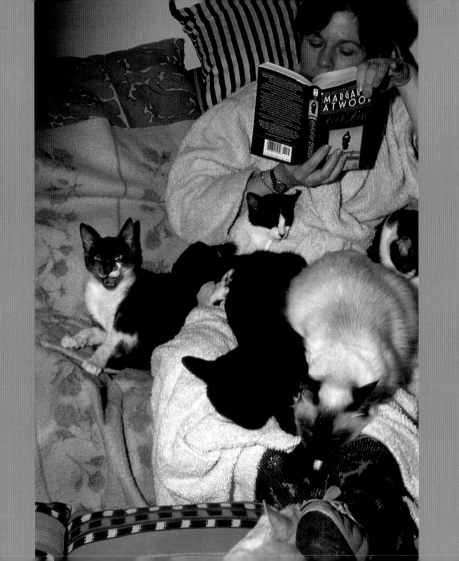

because they fall asleep easily

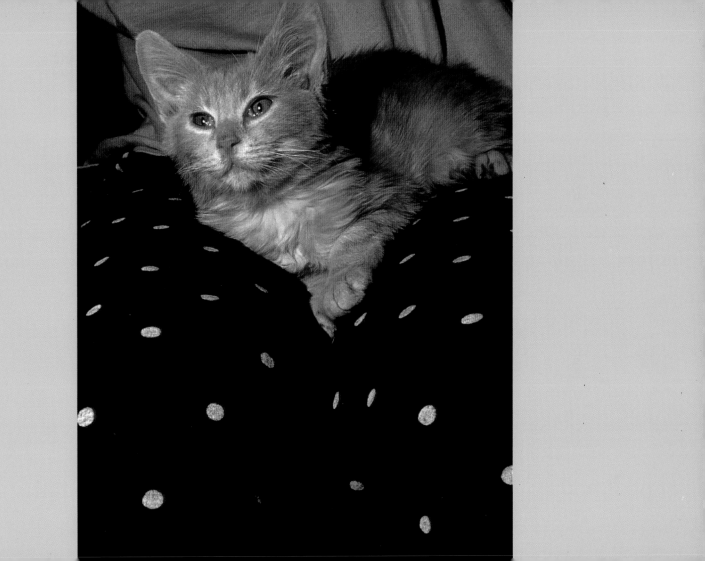

they

because

our

heating

lower

costs

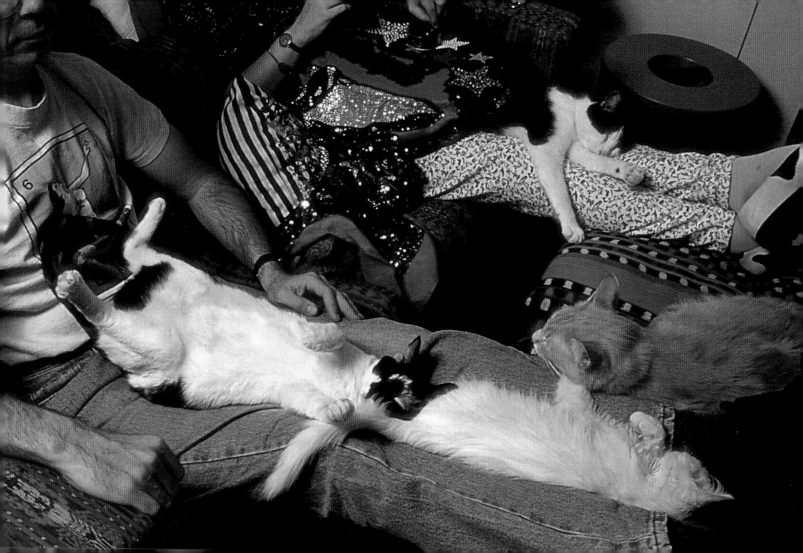

because they're always there

for us

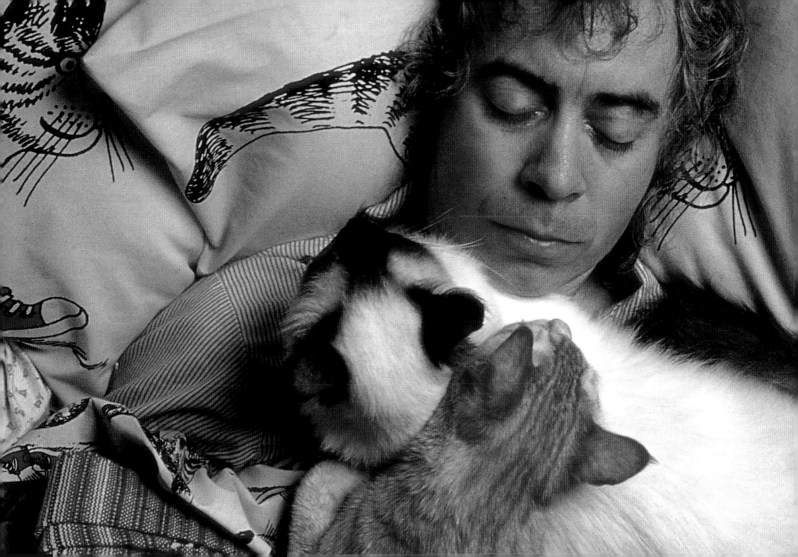

because they come in all stripes and persuasions

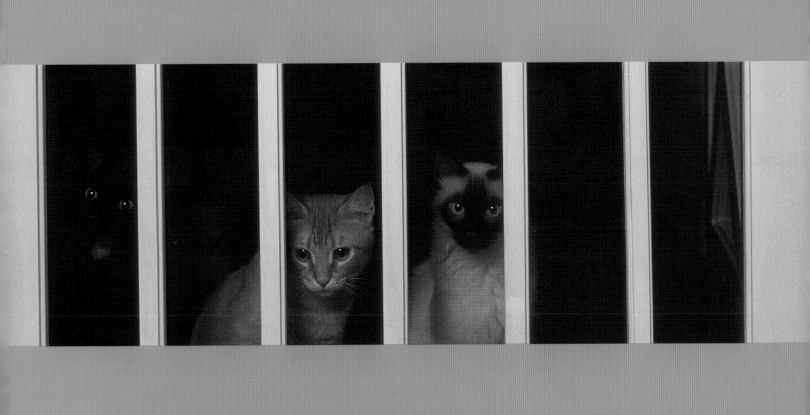

because *each is* *unique*

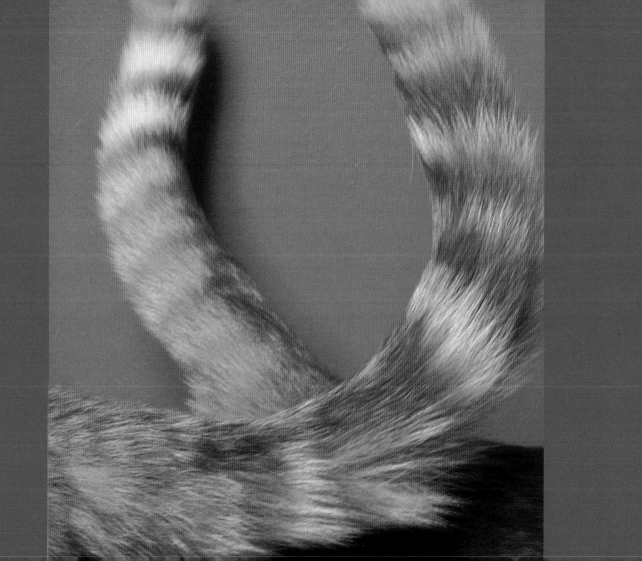

because they're the use of the genuine article

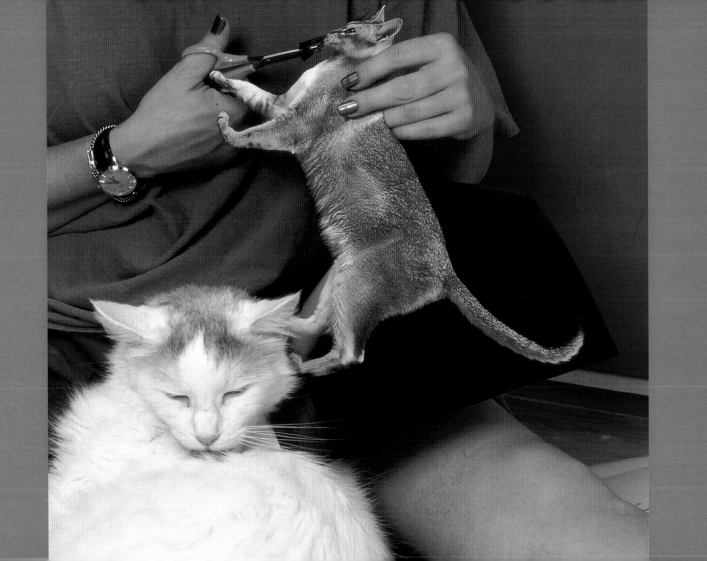

because they can be angelic

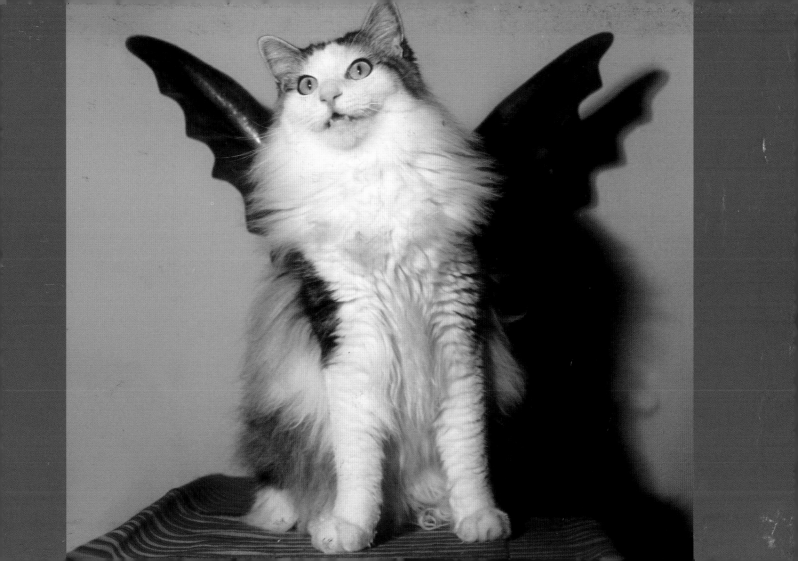